Chich...

...we

...nes

...ele...

The Pepin Press / Agile Rabbit editions
P.O. Box 10349
1001 EH Amsterdam
The Netherlands

Tel +31 20 4202021
Fax +31 20 4201152
mail@pepinpress.com
www.pepinpress.com
www.agilerabbit.com

Concept & series editor:
Pepin van Roojen
Layout for this volume:
Pepin van Roojen, Kitty Molenaar
Cover design:
Kitty Molenaar

isbn 90 5768 055 6

7 6 5 4 3
2006 05

Manufactured in Singapore

SIGNS & SYMBOLS

SIGNES & SYMBOLES • SIGNOS & SÍMBOLOS • ZEICHEN & SYMBOLE
標記和符號 • SEGNI & SIMBOLI • SINAIS & SÍMBOLOS • 記号とシンボル

The Pepin Press – Agile Rabbit Editions

Graphic Themes & Pictures

Textile Patterns

Miscellaneous

Styles (Historical)

Styles (Cultural)

Photographs

Web Design

Folding & Packaging

More titles in preparation
In addition to the Agile Rabbit series of book+CD-ROM sets, The Pepin Press publishes a wide range of books on art, design, architecture, applied art, and popular culture.

Please visit www.pepinpress.com for more information.

Contents

English

This book contains images for use as a graphic resource, or inspiration. All the illustrations are stored in high-resolution format on the enclosed free CD-ROM (Mac and Windows) and are ready to use for professional quality printed media and web page design. The pictures can also be used to produce postcards, either on paper or digitally, or to decorate your letters, flyers, etc. They can be imported directly from the CD into most design, image-manipulation, illustration, word-processing and e-mail programs; no installation is required. Some programs will allow you to access the images directly; in others, you will first have to create a document, and then import the images. Please consult your software manual for instructions.
The names of the files on the CD-ROM correspond with the page numbers in this book. For pages with more than one image, the order is from left to right and from top to bottom. This is indicated with a number following the page number, or with the following letter codes: T = top, B = bottom, C = centre, L = left, and R = right.
The CD-ROM comes free with this book, but is not for sale separately. The publishers do not accept any responsibility should the CD not be compatible with your system.
For non-professional applications, single images can be used free of charge. The images cannot be used for any type of commercial or otherwise professional application – including all types of printed or digital publications – without prior permission from The Pepin Press/Agile Rabbit Editions.

For inquiries about permissions and fees:
mail@pepinpress.com
Fax +31 20 4201152

Deutsch

Dieses Buch enthält Bilder, die als Ausgangsmaterial für graphische Zwecke oder als Anregung genutzt werden können. Alle Abbildungen sind in hoher Auflösung auf der beiliegenden Gratis-CD–ROM (für Mac und Windows) gespeichert und lassen sich direkt zum Drucken in professioneller Qualität oder zur Gestaltung von Websites einsetzen. Sie können sie auch als Motive für Postkarten auf Karton oder in digitaler Form, oder als Ausschmückung für Ihre Briefe, Flyer etc. verwenden.

Die Bilder lassen sich direkt in die meisten Zeichen-, Bildbearbeitungs-, Illustrations-, Textverarbeitungs- und E-Mail-Programme laden, ohne dass zusätzliche Programme installiert werden müssen. In einigen Programmen können die Dokumente direkt geladen werden, in anderen müssen Sie zuerst ein Dokument anlegen und können dann die Datei importieren. Genauere Hinweise dazu finden Sie im Handbuch zu Ihrer Software.

Die Namen der Bilddateien auf der CD–ROM entsprechen den Seitenzahlen dieses Buchs. Bei Seiten mit mehreren Bildern verläuft die Reihenfolge von links nach rechts und oben nach unten. Wo die Position auf der jeweiligen Seite angegeben ist, bedeutet T (top)= oben, B (bottom)= unten, C (centre)= Mitte, L (left)= links und R (right)= rechts.

Die CD–ROM wird kostenlos mit dem Buch geliefert und ist nicht separat verkäuflich. Der Verlag haftet nicht für Inkompatibilität der CD–ROM mit Ihrem System.

Für nicht professionelle Anwendungen können einzelne Bilder kostenfrei genutzt werden. Die Bilder dürfen ohne vorherige Genehmigung von The Pepin Press /Agile Rabbit Editions nicht für kommerzielle oder sonstige professionelle Anwendungen einschließlich aller Arten von gedruckten oder digitalen Medien eingesetzt werden.

Für Fragen zu Genehmigungen und Preisen wenden Sie sich bitte an:
mail@pepinpress.com
Fax +31 20 4201152

Français

Cet ouvrage renferme des illustrations destinées à servir de ressources graphiques ou d'inspiration. La totalité des images sont stockées en format haute définition sur le CD-ROM gratuit inclus (Mac et Windows), prêtes à l'emploi en vue de réaliser des impressions ou pages Web de qualité professionnelle. Elles permettent également de créer des cartes postales, aussi bien sur papier que virtuelles, ou d'agrémenter vos courriers, prospectus et autres.

Vous pouvez les importer directement à partir du CD dans la plupart des applications de création, manipulation graphique, illustration, traitement de texte et messagerie, sans qu'aucune installation ne soit nécessaire. Certaines applications permettent d'accéder directement aux images, tandis que dans d'autres, vous devez d'abord créer un document, puis importer les images. Veuillez consultez les instructions dans le manuel du logiciel concerné.

Sur le CD, les noms des fichiers correspondent aux numéros de pages de ce livre. Sur les pages qui comportent plusieurs images, l'ordre va de gauche à droite, et de haut en bas. Il est indiqué soit par un numéro figurant après le numéro de page, soit par les codes suivants : T (top)= haut, B (bottom)= bas, C (centre)= centre, L (left)= gauche, et R (right)= droite.

Le CD-ROM est fourni gratuitement avec le livre, mais il ne peut être vendu séparément. L'éditeur décline toute responsabilité si ce CD n'est pas compatible avec votre ordinateur.

Vous pouvez utiliser les images individuelles sans frais dans des applications non-professionnelles. Il est interdit d'utiliser les images avec des applications de type professionnel ou commercial (y compris toutes les sortes de publications numériques ou imprimés) sans l'autorisation préalable de The Pepin Press/Agile Rabbit Editions.

Pour tout renseignement relatif aux autorisations et aux frais d'utilisation:
mail@pepinpress.com
Fax +31 20 4201152

Italiano

Questo libro contiene immagini che possono essere utilizzate come risorsa grafica o come fonte di ispirazione. Tutte le illustrazioni sono contenute nell'allegato CD–ROM gratuito (per Mac e Windows), in formato ad alta risoluzione e pronte per essere utilizzate per pubblicazioni professionali e pagine web. Possono essere inoltre usate per creare cartoline, su carta o digitali, o per abbellire lettere, opuscoli, ecc.

Dal CD, le immagini possono essere importate direttamente nella maggior parte dei programmi di grafica, di ritocco, di illustrazione, di scrittura e di posta elettronica; non è richiesto alcun tipo di installazione. Alcuni programmi vi consentiranno di accedere alle immagini direttamente; in altri, invece, dovrete prima creare un documento e poi importare le immagini. Consultate il manuale del software per maggiori informazioni.

I nomi dei documenti sul CD–ROM corrispondono ai numeri delle pagine del libro. Quando le pagine contengono più di un'immagine, l'ordine di queste ultime è da sinistra a destra e dall'alto verso il basso. L'ordine è indicato con un numero situato dopo il numero di pagina o con le seguenti lettere: T (top)= alto, B (bottom)= basso, C (centre)= centro, L (left)= sinistra e R (right)= destra.

Il CD–ROM è allegato gratuitamente al libro e non può essere venduto separatamente. L'editore non può essere ritenuto responsabile qualora il CD non fosse compatibile con il sistema posseduto.

Per applicazioni di tipo non professionale, le singole immagini possono essere utilizzate gratuitamente. Se desiderate, invece, utilizzare le immagini per applicazioni di tipo professionale o con scopi commerciali, comprese tutte le pubblicazioni digitali o stampate, sarà necessaria la relativa autorizzazione da parte della casa editrice The Pepin Press/Agile Rabbit Editions.

Per ulteriori informazioni su autorizzazioni e canoni per il diritto di sfruttamento commerciale rivolgetevi a:
mail@pepinpress.com
Fax +31 20 4201152

Español

En este libro podrá encontrar imágenes que le servirán como fuente de material gráfico o como inspiración para realizar sus propios diseños. Se adjunta un CD-ROM gratuito (Mac y Windows) donde hallará todas las ilustraciones en un formato de alta resolución, con las que podrá conseguir una impresión de calidad profesional y diseñar páginas web. Las imágenes pueden también emplearse para realizar postales, de papel o digitales, o para decorar cartas, folletos, etc.

Estas imágenes se pueden importar desde el CD a la mayoría de programas de diseño, manipulación de imágenes, dibujo, tratamiento de textos y correo electrónico, sin necesidad de utilizar un programa de instalación. Algunos programas le permitirán acceder a las imágenes directamente; otros, sin embargo, requieren la creación previa de un documento para importar las imágenes. Consulte su manual de software en caso de duda.

Los nombres de los archivos del CD-ROM se corresponden con los números de página de este libro. En aquellas páginas en las que haya más de una imagen, el orden que se ha de seguir para localizarlas es de izquierda a derecha y de arriba abajo. Esto se indica con un número a continuación del número de página, o con las siguientes abreviaturas: T (top)= arriba; B (bottom)= abajo; C (centre)= centro; L (left)= izquierda y R (right)= derecha.

El CD-ROM se ofrece de manera gratuita con este libro, pero está prohibida su venta por separado. Los editores no asumen ninguna responsabilidad en el caso de que el CD no sea compatible con su sistema.

Se autoriza el uso de estas imágenes de manera gratuita para aplicaciones no profesionales. No se podrán emplear en aplicaciones de tipo profesional o comercial (incluido cualquier tipo de publicación impresa o digital) sin la autorización previa de The Pepin Press/Agile Rabbit Editions.

Para más información acerca de autorizaciones y tarifas:
mail@pepinpress.com
Fax +31 20 4201152

Português

Este livro contém imagens que podem ser utilizadas como fonte de material gráfico ou como inspiração para realizar os seus próprios desenhos. Você encontrará todas as ilustrações em formato de alta resolução dentro do CD-ROM gratuito (Mac e Windows), e com elas poderá conseguir uma impressão de qualidade profissional e desenhar páginas web. As imagens também podem ser usadas para criar postais, de papel ou digitais, ou para decorar cartas, folhetos, etc. Estas imagens podem ser importadas do CD para a maioria de programas de desenho, manipulação de imagem, ilustração, processamento de texto e correio eletrônico, sem a necessidade de utilizar um programa de instalação. Alguns programas permitirão que você tenha acesso às imagens diretamente; e em outros, você deverá criar um documento antes de importar as imagens. Por favor, consulte o seu manual de software para obter maiores informações.

Os nomes dos arquivos do CD-ROM correspondem aos números de página deste livro. Nas páginas onde exista mais de uma imagem, a ordem que deve ser seguida para localizar as imagens é da esquerda para a direita e de cima para baixo. Isso é indicado com um número que vem logo depois do número de página, ou com as seguintes abreviaturas: T (top)= acima; B (bottom)= abaixo; C (centre)= centro; L (left)= esquerda e R (right)= direita.

O CD-ROM é oferecido de forma gratuita com este livro, porém é proibido vendê-lo separadamente. Os editores não assumem nenhuma responsabilidade no caso de que o CD não seja compatível com o seu sistema.

Desde que não seja para aplicação profissional, as imagens individuais podem ser utilizadas gratuitamente. As imagens não podem ser empregadas em nenhum tipo de aplicação comercial ou profissional - incluindo todos os tipos de publicações impressas ou digitais - sem a prévia permissão de The Pepin Press/Agile Rabbit Editions.

Para esclarecer dúvidas a respeito das permissões e taxas:
mail@pepinpress.com
Fax +31 20 4201152

日本語

本書にはグラフィック リソースやインスピレーションとして使用できる美しいイメージ画像が含まれています。すべてのイラストレーションは、無料の付属 CD-ROM (Mac および Windows 用) に高解像度で保存されており、これらを利用してプロ品質の印刷物や WEB ページを簡単に作成することができます。また、紙ベースまたはデジタルの葉書の作成やレター、ちらしの装飾等に使用することもできます。

これらの画像は、CD から主なデザイン、画像処理、イラスト、ワープロ、E メールソフトウェアに直接取り込むことができます。インストレーションは必要ありません。プログラムによっては、画像に直接アクセスできる場合や、一旦ドキュメントを作成した後に画像を取り込む場合等があります。詳細は、ご使用のソフトウェアのマニュアルをご参照下さい。

CD-ROM 上のファイル名は、本書のページ数に対応しています。ページに複数の画像が含まれる場合は、左から右、上から下の順番で番号がつけられ、ページ番号に続く数字または下記のレターコードで識別されます。

T =トップ (上部)、B= ボトム (下部)、C =センター (中央)、L= レフト (左) R =ライト (右)

CD-ROM は本書の付属品であり、別売されておりません。CD がお客様のシステムと互換でなかった場合、発行者は責任を負わないことをご了承下さい。

プロ用以外のアプリケーションで、画像を一回のみ無料で使用することができます。The Pepin Press / Agile Rabbit Editions から事前許可を得ることなく、あらゆる形体の印刷物、デジタル出版物をはじめとする、あらゆる種類の商業用ならびにプロ用アプリケーションで画像を使用することを禁止します。

使用許可と料金については、下記までお問い合わせ下さい。

mail@pepinpress.com

ファックス: +31 20 4201152

中 文

本書包含精美圖片，可以作為圖片資源或激發靈感的資料使用。這些圖片存儲在所附的高清晰度
免費 CD-ROM (可在 Mac 和 Windows 下使用) 中，可用於專業的高品質印刷媒體和網頁設計。圖
片還可以用於製作紙質和數字明信片，或裝飾您的信封、傳單等。您無需安裝即可以把圖片直接
從 CD 調入大多數的設計、圖像處理、圖片、文字處理和電子郵件程序。有些程序允許您直接使
用圖片；另外一些，您則需要先創建一個文件，然後引入圖片。用法說明請參閱軟體說明書。

在 CD 中的文件名稱是與書中的頁碼相對應的。如果書頁中的圖片超過一幅，其順序為從左到
右，從上到下。這會在書頁號後加一個數字來表示，或者是加一個字母： T = 上， B = 下，
C = 中，L = 左，R = 右。

本書附帶的 CD-ROM 是免費的，但 CD-ROM 不單獨出售。如果 CD 與您的系統不相容，出版商不
承擔任何責任。

就非專業的用途而言，可以免費使用單個圖片。若未事先得到 The Pepin Press/Agile Rabbit Editions
的許可，不得將圖片用於任何其他類型的商業或專業用途 - 包括所有類型的印刷或數字出版物。

有關許可及收費的詢問，請查詢：

Mail@pepinpress.com

傳真： +31 20 4201152

14th–16th-century Notary Signets

Notariatsignete aus dem 14.–16. Jahrhundert

Signos de los notarios del siglo XIV al siglo XVI

Seings de tabellions du XIVe au XVIe siècle

Sigilli norarili (XIV–XVI sec.)

Sinetes Notariais do Século XIV ao Século XVI

14 〜 16 世紀の認印

14-16 世紀時公證人的印信

Georgius
Bruyyberger

Signetum N. Proprium
Ioannis Conradi Linden Ziensis

p. Pabl.

Tomadiß
grund;

Heraldry

Heraldik

La heráldica

Héraldique

L'araldica

Heráldica

紋章

紋章學

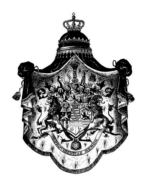

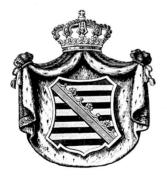

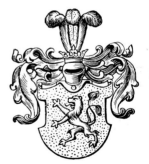

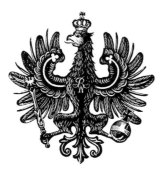

Per aspera ad astra

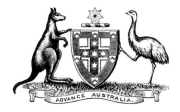

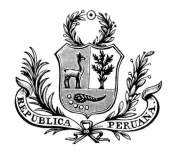

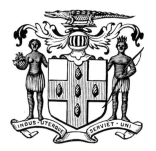

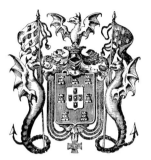

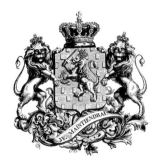

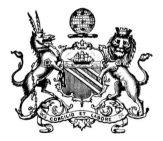

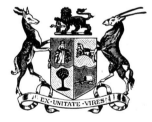

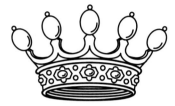

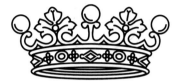

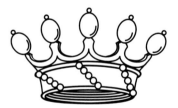

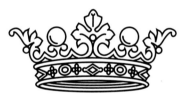

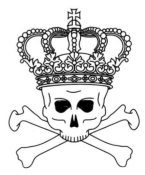

19th-century French Hand Signs for the Deaf

Französische Handzeichen des 19. Jahrhunderts für Taubstumme

Signos franceses del lenguaje para sordomudos del siglo XIX

Signes français du langage des sourds du XIXe siècle

I segni del linguaggio gestuale francese del XIX sec.

Sinais de Língua Gestual Francesa do Século XIX

19 世紀フランスの手話記号

19 世紀時聾人之法式手語記號

A

B

C

D

E

F

G

H

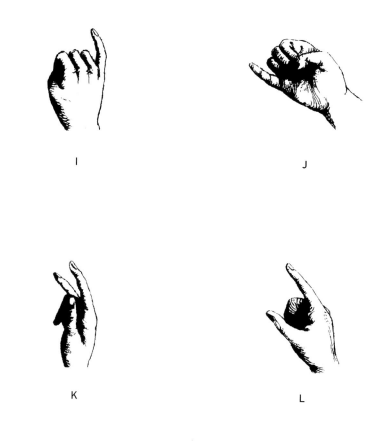

I

J

K

L

M

N

O

P

Q

R

S

T

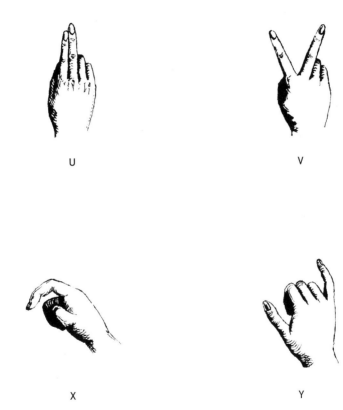

U

V

X

Y

19th-century Symbols of Professions and Organisations

Symbole des 19. Jahrhunderts für Berufe und Organisationen

Símbolos de profesiones, oficios y organizaciones del siglo XIX

Symboles de professions, métiers et organisations du XIX e siècle

I simboli delle professioni e delle organzzazioni del XIX sec.

Símbolos de Profissões e Organizações do Século XIX

19 世紀の職業と団体関連の記号

19 世紀時的職業和階級制度的符號

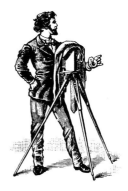

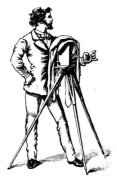

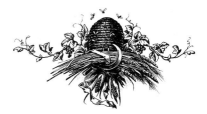

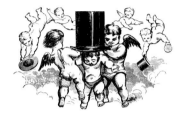

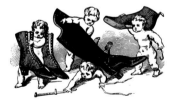

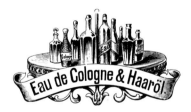

Eau de Cologne & Haaröl.

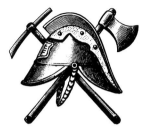

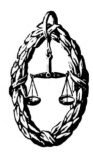

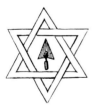

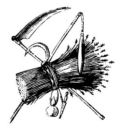

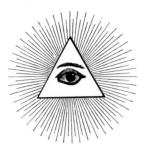

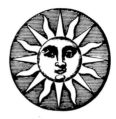

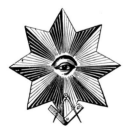

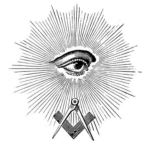

Property Marks

Eigentumszeichen

Marcas de propiedad

Marques de propriété

Marche di proprietà

Marcas de Propriedade

不動産関係の記号

財產標記

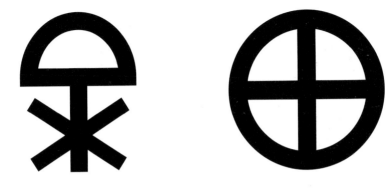

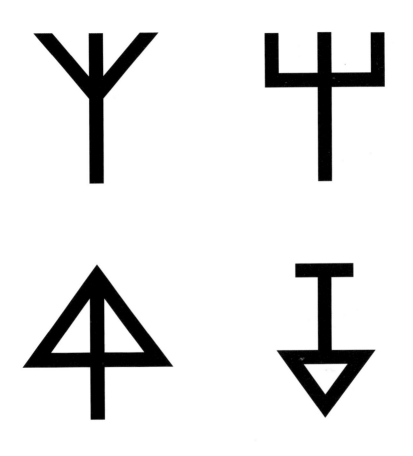

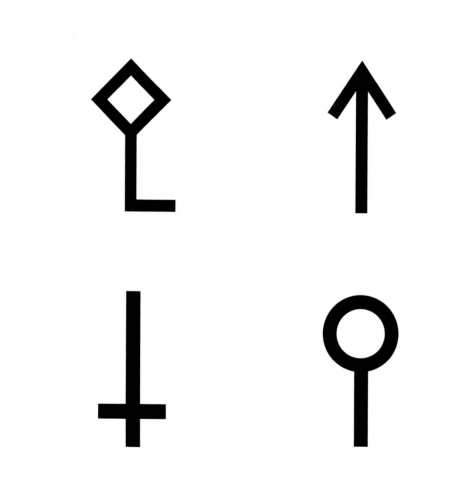

The Calendar

Kalender

El calendario

Le calendrier

Il calendario

O calendario

カレンダー

日曆

SEPTEMBER

OCTOBER

NOVEMBER

DECEMBER

Januar

Februar

Maerz

April

The Arrow and the Cross

Pfeil und Kreuz

La flecha y la cruz

La flèche et la croix

La freccia e la croce

A Seta e a Cruz

矢印と十字

弓形和十字形

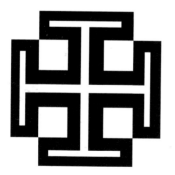

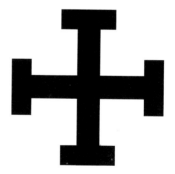

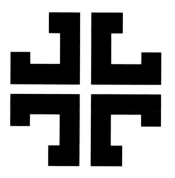 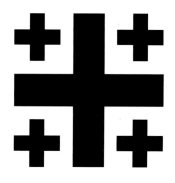

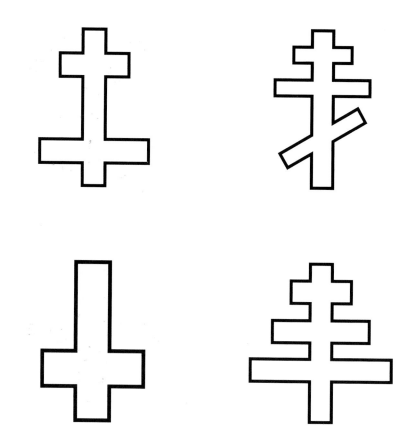

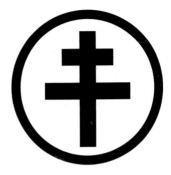

The Star and the Crescent

Stern und Sichel

La estrella y la media

L'etoile et la faucille

La stella e la mezzaluna

A Estrela e o Crescente

星と三日月形

星形和新月形

Japanese Coats of Arms

Japanische Wappen

Escudos de armas japoneses

Blasons japonais

Stemme giapponesi

Brasões Japoneses

日本の紋

日本之紋章

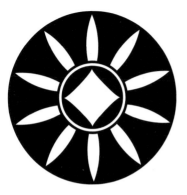 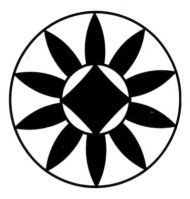

Meanders and Swatikas

Mäanders und Swastikas

Meandros y esvásticas

Méandres et svastikas

Meandri e svastiche

Meandros e Suásticas

曲折模様と鉤十字

迷宮圖案

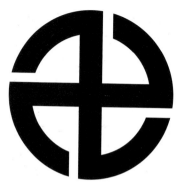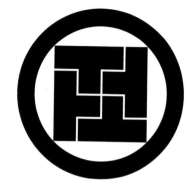

African Akan Symbols

Afrikanische Symbole der Akan

Symbôles africains akans

Simboli akan africani

Símbolos akan africanos

Símbolos Akan Africanos

アフリカ・アカン族の記号

非洲亞堪族之符號

165

Ancient Chemical Symbols

Alte chemische Zeichen

Símbolos químicos antiguos

Anciens symboles chimiques

Antichi simboli chimici

Símbolos Químicos Antigos

古代の薬記号

遠古的化學符號

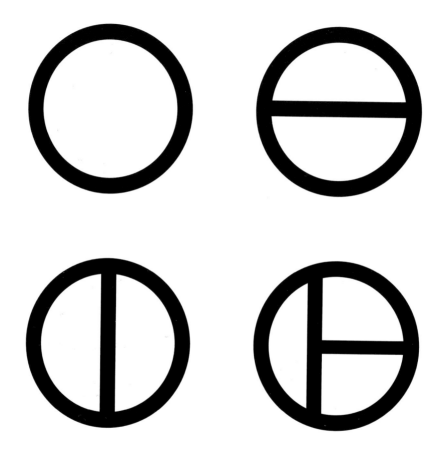

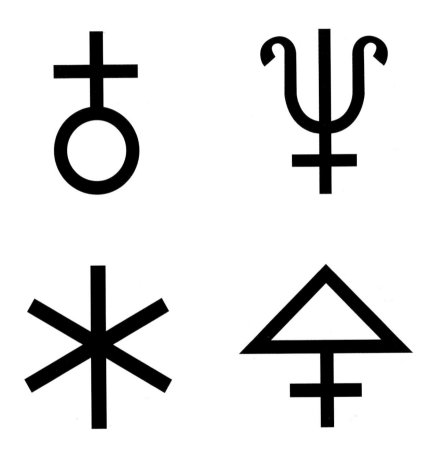

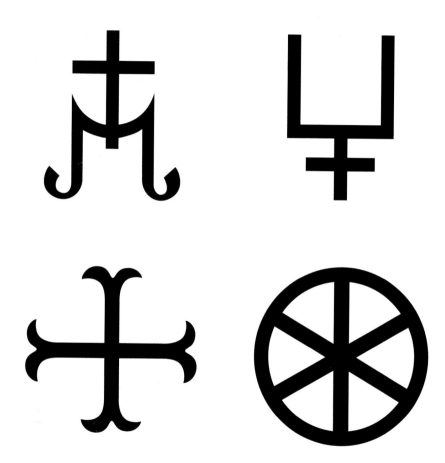

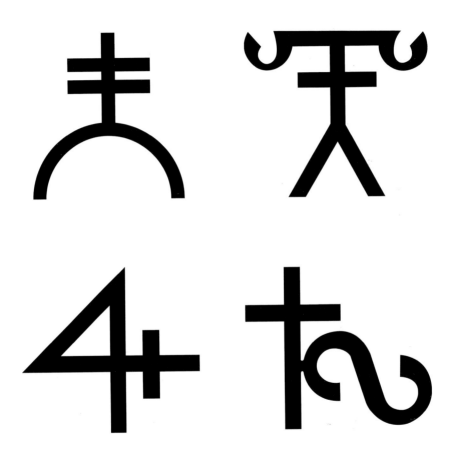

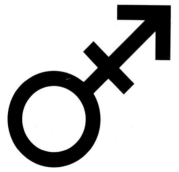

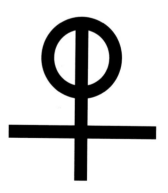

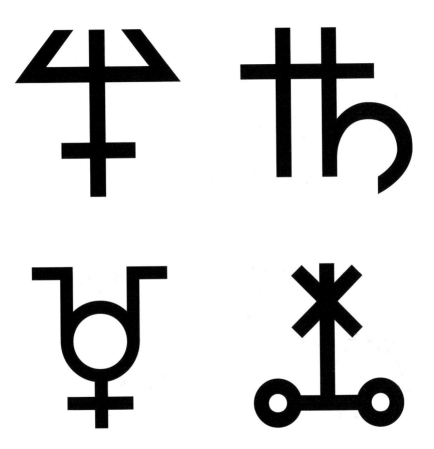

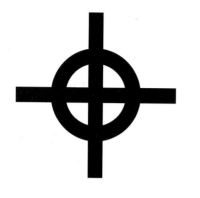

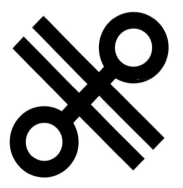

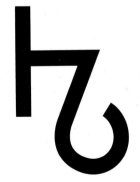

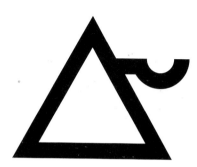

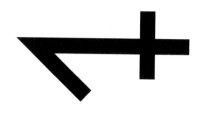

Gold and silver

Gold und Silber

Or et argent

Oro e argento

Oro y plata

Ouro e Prata

ゴールドとシルバー

黄金和白銀

Mathematical Symbols

Mathematische Zeichen

Signos matemáticos

Symboles mathématiques

Segni matematici

Símbolos Matemáticos

数学記号

數學符號

187

Electrical Symbols

Elektrische Zeichen

Signos eléctricos

Symboles électriques

Segni elettrici

Símbolos Eléctricos

電気記号

電的符號

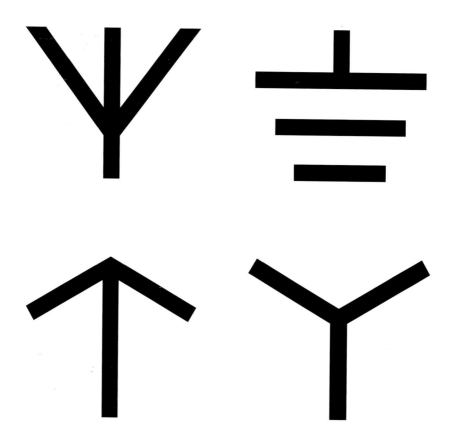

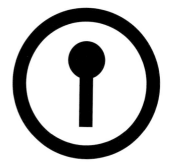

Meteorological Symbols

Meteorologische Zeichen

Símbolos meteorológicos

Symboles météorologiques

Segni meteorologici

Símbolos Meteorológicos

気象記号

氣象符號

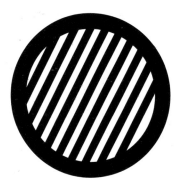
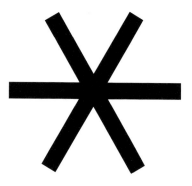
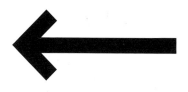

Religion and mystic

Religion und Mystisches

Religion et mystique

Religione e misticismo

Religión y mística

Religião e Misticismo

宗教

宗教

Family

Familie

famille

famiglia

Familia

Família

ファミリー

家族

People

Personen

Personnes

Persone

Personas

Pessoas

人々

人

240

241

242

243

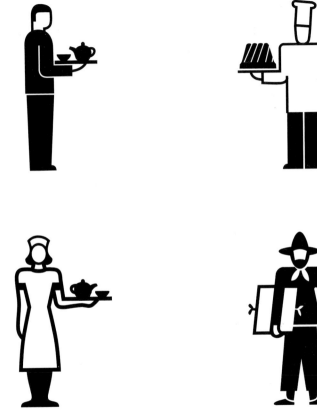

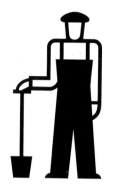

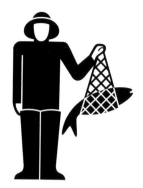

Health and safety

Gesundheit und Sicherheit

Santé et sécurité

Salute e sicurezza

Seguridad y salud

Saúde e Segurança

衛生と安全

衛生安全

Sports

Sport

El deporte

Sport

Sport

Desporto

スポーツ

運動

279

Travel and traffic

Reise und Verkehr

Voyages et signalisation routière

Viaggi e segnali stradali

Viajes y tráfico

Viagens e Trânsito

旅行と交通機関

旅遊和交通

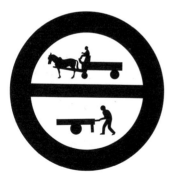

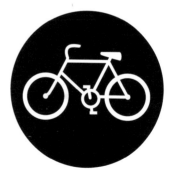

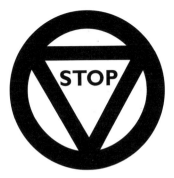 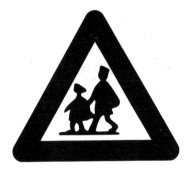

294

300

Clothing and washing

Bekleidung und Waschen

Vêtements et Entretien

Abiti e lavaggio

Ropa y limpieza

Vestuário e Lavagem

衣類と洗濯記号

衣服和洗滌

315

General Signs and Symbols

Allgemeine Zeichen und Symbole

Signos y símbolos generales

Signes et symboles généraux

Segni e simboli generali

Sinais e Símbolos Genéricos

一般的な記号とシンボル

一般的標記和符號

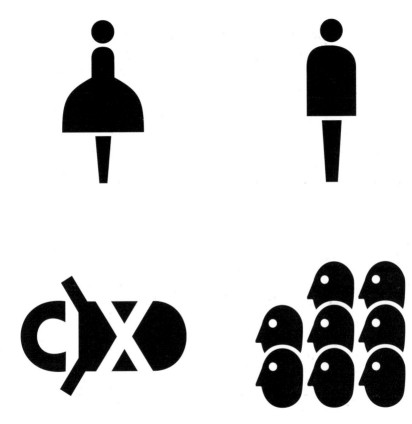

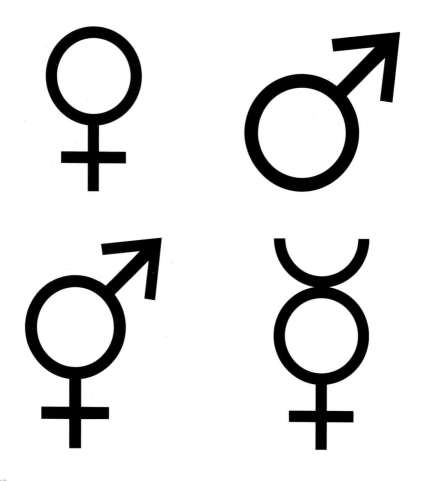

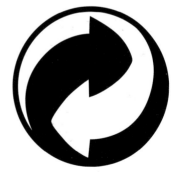

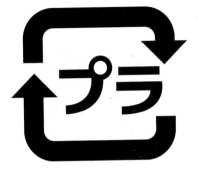

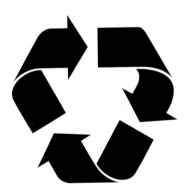

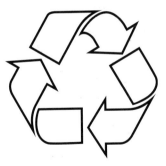

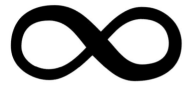

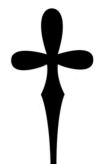

341

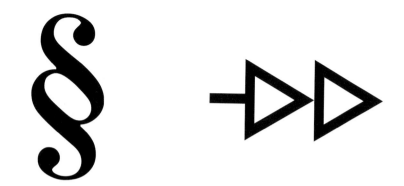

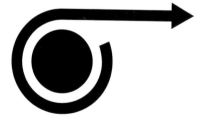

344

347

Index of chapters

Index of images

| | | | | | | |
|---|---|---|---|---|---|
| 89 BR | Maltese cross | 165 TR | Woman is the nation | 178 TR | Glass |
| 96 BL | Cross of Burgundy/St. Andrew | 165 BL | God | 178 BL | Precipitate |
| 96 BR | Cross of Burgundy/St. Andrew | 165 BR | Our well-being | 178 BR | Sublimate |
| 97 TL,R | Latin or French cross | 168 TL | Alum | 179 TL | Tin |
| 97 BL,R | Cross of the Russian Orthodox | 168 TR | Salt | 179 TR | Vitriol |
| | Church | 168 BL | Niter | 179 BL | Water |
| 98 TR | Cross of Jerusalem | 168 BR | Vitriol | 179 BR | Steel |
| 98 BL,R | Cross of crutches | 169 TL,R | Antimony | 1182 | Gold |
| 99 TL | Cross of crutches | 169 BL | Ammoniac | 183 TL, R | Gold |
| 99 TR | Cross of the crusaders | 169 BR | Sulphur | 183 BL | Gold |
| 99 BL | Cross of Jerusalem | 170 TL | Alum | 183 BR | Silver |
| 99 BR | German cross | 170 TR | Potash | 184 TL,R | Silver |
| 100 TL | Cross of anchors | 170 BL | White lead | 186 TL | Half circle |
| 101 TL | Maltese cross | 170 BR | Verdigris | 186 TR | Segment |
| 101 TR | Croix pommée | 171 TL | Amalgam | 186 BL | Cycle |
| 101 BL | Croix pommée | 171 TR | Lead | 186 BR | Arc |
| 101 BR | Croix recercelée | 171 BL | Borax | 187 TL | Diameter |
| 102 TL | Croix patée fichée | 171 BR | Arsenic | 187 TR | Average |
| 102 TR | Croix patée fichée | 172 TL | Tree oil | 187 BL | Trace of... |
| 102 BL | Croix patée fichée | 172 TR | Blood stone | 187 BR | Centre |
| 102 BR | Cross of churches | 172 BL | Iron saphron | 188 TL | Triangular point |
| 111 TL,R | Cross of the patriarchs | 172 BR | Bolus | 188 TR | Triangle |
| 120 TL,R | Divine trinity, eternity, | 173 TL | Essence | 188 BL | Trigonometrical point |
| | and indivisibility | 173 TR | Lead oil | 188 BR | Square |
| 121 TL,R | Divine trinity, eternity, and | 173 BL | Minium | 189 TL | Falling pressure |
| | indivisibility | 173 BR | Auripigment | 189 TR | Rising pressure |
| 124 TL | Mercedes | 174 TL | Crystallized verdigris | 189 BL | Infinitely small quantity |
| 124 BR | Pythagorean symbol of health | 174 TR | Copper water | 189 BR | Point of change |
| 125 TL | Star of David / Seal of Solomon | 174 BL | Nitric acid (aqua fortis) | 192 TL | Aerial |
| 135 TL | Symbol of Islam | 174 BR | Urine | 192 TR | Earth |
| 162 TL | Totality of the universe | 175 TL | Metallic calcium | 192 BL | Aerial |
| 162 TR | Spirituality | 175 TR | Calcium | 192 BR | Star-shaped circuit |
| 162 BL | Parenthood | 175 BL | Copper saphron | 193 TL | Record-player |
| 162 BR | Unequal economic relations | 175 BR | Lapis lazuli | 193 TR | Ohm |
| 163 TL | Hope | 176 TL | Lye | 193 BL | Microphone |
| 163 TR | Permanency of the human soul | 176 TR | Wax | 193 BR | AC |
| 163 BL | Peace, calmness | 176 BL | Vinegar | 194 TL | Electric valve |
| 163 BR | Power | 176 BR | Feather white | 194 TR | Triangular circuit |
| 164 TL | Household | 177 TL | Tartar | 194 BL | Fixed lighting fixture |
| 164 TR | Sanctity | 177 TR | Brandy (spirit of wine) | 194 BR | Fixed lighting fixture with switch |
| 164 BL | Unequal opportunity | 177 BL | Metallic calcium | 195 TL | Fuse |
| 164 BR | Self-reliance | 177 BR | Iron | 195 TR | Loudspeaker |
| 165 TL | Omnipotence | 178 TL | Wood | 195 BL | Bulb |

195 BR	High tension
196 TL	Continuous line (switched on)
196 TR	Interrupted line (Switched off)
196 BL	Automatic
196 BR	Manual
197 TL	Minus pole on the left
197 TR	Minus pole on the right
197 BL	Fuse element
197 BR	Neutral electrode
198 TL,R	Radiation quantities
198 BL	Dangerous interference
198 BR	Two parallel lines
199	Radiation quantities
200 TL	Endoscopy
200 TR	Spark gap
200 BL	Measurement region 6
200 BR	Measurement region 60
201 TL	Tube current
201 TR	Spark gap current
201 BL	Galvanic current
201 BR	Faradic current
202 TL	Trapeze current
202 TR	Delta current
202 BL	Threshold current
202 BR	Constant current
203 TL	Two probes radiating
203 TR	One probe radiating
203 BL	Caustic
203 BR	Fulguration
204 TL	Cutting
204 TR	Pedal switch
204 BL	Resection
204 BR	Coagulation
206 TL	Rain
206 TR	Snow
206 BL	Ice needles
206 BR	Sleet
207 TL	Snow flurries
207 TR	Snow cover
207 BL	Hail
207 BR	Ice pellets
208 TL	Hoar frost
208 TR	Dew
208 BL	Thunder
208 BR	Storm
209 TL	Haze
209 TR	Brume

209 BL	White frost
209 BR	Fog
210 TL	Lightning
210 TR	Rainbow
210 BL	Lunar halo
210 BR	Lunar aureole
211 TL	Solar halo
211 TR	Solar aureole
211 BL	Polar aureole
211 BR	Clear sky
212 TL	1/4 clouded
212 TR	1/2 clouded
212 BL	Lunar phase
212 BR	Lunar phase
213 TL	3/4 clouded
213 TR	Clouded
213 BL	Lunar phase
213 BR	Lunar phase
214 TL	Sun
214 TR	Bright sun
214 BL	Bright
214 BR	Cloudy bright
215 TL	Hazy sun
215 TR	Cloudy dull
215 BL	Cloudy bright no shade
215 BR	Heavy overcast
216 TL	Heavy rain
216 TR	hail shower
216 BL	Heavy snow
216 BR	Thunderstorm
217 TL	Cloudy with sleet
217 TR	Winter
217 BL	Cross wind
217 BR	Winter
218 TL	Hurricane
218 TR	Squall
218 BL	Tropical storm
218 BR	Tornado
219 TL	Dust or sand storm
219 TR	Dust whirls
222 TL	Mandala (Hindu)
222 TR	Christianity
222 BL	Buddha
222 BR	Shintoism
223 TL	Taoism
223 TR	Islam
223 BL	Zoroastrianism

223 BR	Confucianism
224 TL	Quoran (Islam)
224 TR	Kosher (Judaism)
224 BL	Halal (Islam)
224 BR	Hinduism
225 TL	Zen
225 TR	Yin-Yang
225 BL	Star of David (Judaism)
225 BR	Judaism
226 TL	Cicada (Chinese)
226 TR	Ghanta (Tibet)
226 BL	Pearl (Chinese)
226 BR	Books (Chinese)
227 TL	Line of Beauty
227 TR	Buddhist Lotus
227 BL	Christian Sacrament
227 BR	Bukranion (Minoic)
228 TL	Hart of Hrungir (Norwegian)
228 TR	Endless knot
228 BL	Buddhism (Tibet)
228 BR	Shri Yantra
229 TL	Nade Takara Nusubi
229 TR	Chakra Vartta
229 BL	Shou
229 BR	Karma
230 TR	Horin Rimbo
230 BL	Holy Trinity
230 BR	Saibaba
231 TL	Lotus
231 TR	Plum blossom (Chinese)
231 BL	Lotus
231 BR	Ankh
232 TL	Utchat Sacred Eye
234 TL	Woman
234 TR	Man
234 BL	Friendship
234 BR	Men fight
235 TL	Procreation
235 TR	Child-bearing
235 BL	Pregnancy
235 BR	Mother & one child
236 TL	Mother dies
236 TR	One child dies
236 BL	Man dies
236 BR	Widow & children
237 TL	The family
237 TR	Surviving child

| | | | | | | | |
|---|---|---|---|---|---|
| 256 TL | High voltage | 267 BR | Nursery | 281 BL | Water polo |
| 256 TR | Do not trip | 268 TL | Mental hygiene | 284 TL | Tunnel |
| 256 BL | Emergency exit | 268 TR | Phoniatrics | 284 TR | End of tunnel |
| 256 BR | Slippery floor | 268 BL | Neurosurgery | 284 BL | Motorway |
| 257 TL | Poison | 268 BR | Psychology | 284 BR | No cars |
| 257 TR | X-rays | 269 TL | Incisor | 285 TL | No push carts |
| 257 BL | Corrosive | 269 TR | Molar | 285 TR | No horse-drawn carriages |
| 257 BR | Biohazard | 269 BL | Incisor | 285 BL | No overtaking |
| 258 TL | Wear gasmask | 269 BR | Molar | 285 BR | No motorbikes |
| 258 TR | Wear goggles | 272 TL | Tracking | 286 TL | No trailers |
| 258 BL | Wear helmet | 272 TR | Hiking | 286 TR | No motorized vehicles |
| 258 BR | Keep out! | 272 BL | Cycling | 286 BL | No carriages |
| 259 TL | No pictures | 272 BR | Horseback riding | 286 BR | Bicycle path |
| 259 TR | No ties | 273 TL | Fishing | 287 TL | Stop |
| 259 BL | No dogs | 273 TR | Fencing | 287 TR | Caution: children |
| 259 BR | No mobile phones | 273 BL | Archery | 287 BL | No entry |
| 260 TL | Handle with care | 273 BR | Shooting | 287 BR | Roundabout |
| 260 TR | Wheelchair | 274 TL | Judo | 288 TL | Major road |
| 260 BL | Camera supervision | 274 TR | Boxing | 288 TR | Yield |
| 260 BR | Handle with care | 274 BL | Weight lifting | 288 BL | No entry |
| 261 TL | Pharmacy | 274 BR | Wrestling | 288 BR | Intersection with right of way |
| 261 TR | Blood donor | 275 TL | Baseball | 289 TL | Yield to oncoming traffic |
| 261 BL | Aesculapius | 275 TR | Handball | 289 TR | Right of way over oncoming |
| 261 BR | Liquids | 275 BL | Soccer | | traffic |
| 262 TL | No fire | 275 BR | Volleyball | 289 BL | Right turn |
| 262 TR | Fire hose | 276 TL | Hockey | 289 BR | Straight only |
| 262 BL | Inflammable materials | 276 TR | Ice Hockey | 290 TL,R | No parking |
| 262 BR | Fire alarm | 276 BL | Gymnastics | 290 BL | No stopping at any time |
| 263 TL | Fire extinguisher | 276 BR | Skating | 290 BR | Parking |
| 263 TR | Non-ionizing | 277 TL | Speed skating | 291 TL | Slippery Road |
| 263 BL | Smoking | 277 TR | Biathlon | 291 TR | Quayside |
| 263 BR | Non-smoking | 277 BL | Figure skating | 291 BL | Road-work ahead |
| 264 TL | Uranium | 277 BR | Cross-country skiing | 291 BR | Falling rocks |
| 264 TR | Poison | 278 TL | Bob | 292 TL | Handcarts |
| 264 BL | Fallout shelter | 278 TR | Bobsleigh | 292 TR | Animal-drawn vehicle |
| 264 BR | Radiation | 278 BL | Luge | 292 BL | Emergency road |
| 265 TL | Laboratory | 278 BR | Sledding | 292 BR | Parking |
| 265 TR | Insecticide & sterilizer | 279 TL | Cross-country skiing | 293 TL | Ship |
| 265 BL | Sterilizer | 279 TR | Slalom | 293 TR | Bus |
| 265 BR | Insecticide | 279 BL | Downhill skiing | 293 BL | Airport |
| 266 TL | Rehab | 279 BR | Ski jumping | 293 BR | Taxi |
| 266 TR | Pulmonary physiology | 280 TL | Diving | 294 | Approaching railway track |
| 266 BL | Physiotherapy | 280 TR | Rowing | 295 TL,R | Approaching railway tracks |
| 266 BR | Cardiology | 280 BL | Swimming | 295 BL | Approaching railway tracks |
| 267 TL | Infirmary | 280 BR | Canoeing | 295 BR | Train |
| 267 TR | Visitors | 281 TL | Water ski | 296 TL | Cars |
| 267 BL | Maternity | 281 TR | Sailing | 296 TR | Trucks |

296 BL Scooters
296 BR Planes
297 TL Breaker's yard
297 TR Obstacles
297 BL Ambulance
297 BR Hospital
298 TL Trailer site
298 TR Heliport
298 BL Sailboats
298 BR Gas station
299 TL Customs
299 TR Customs
299 BL Customs
299 BR Luggage locker
300 TL Camp-site
300 TR Playground
300 BL Camp fire
300 BR Lift
301 TL Nature trail
301 TR Hiking trail
301 BL Jeep Trail
301 BR Lookout tower
302 TL Cafeteria
302 TR Restaurant
302 BL Picnic site
302 BR Beach
303 TL No honking
303 TR Wheelchair access
303 BL Factory district
306 TL Women's wear
306 TR Men's wear
306 BL Over-garments
306 BR Men's work clothes
307 TL Dresses, skirts, blouses
307 TR Suits
307 BL Men's shirts
307 BR Sweaters, sweatshirts
308 TL Men's sweaters
308 TR Hosiery
308 BL Underwear
308 BR Lingerie
309 TL Shoes
309 TR Socks
309 BL Men's shoes
309 BR Women's shoes
310 TL Hats
310 TR Gloves

310 BL Girls' clothing
310 BR Towels
311 TL Outer garments
311 TR Synthetics/ cotton mixture
311 BL Tricot
311 BR Synthetics
312 TL Curtains
312 TR Dainty clothes
312 BL Cupboard dry
312 BR Wool
313 TL High water level
313 TR Floating washing
313 BL Low water level
313 BR Gentle action washing
314 TL Pre-wash
314 TR Warm washing
314 BL Special treatment
314 BR Rinsing
315 TL Draining
315 TR Drying
315 BL Rinsing with r. agent
315 BR Pump
316 TL Drip proof
316 TR Spin-dry
316 BL Drip proof
318 TL Women
318 TR Men
318 BL Girls
318 BR Boys
319 TL Women
319 TR Men
319 BL Infants
319 BR Group room
320 TL Female
320 TR Male
320 BL Hermaphrodite
320 BR Neuter
321 TL Porter
321 TR Room service
321 BL Waiter
321 BR Chamber maid
322 TL Shower
322 TR Bath
322 BL Washing facility
322 BR Tub
323 TL Shave
323 TR Shave

323 BL Barbershop
323 BR Barbershop
324 TL Beauty parlor
324 TR Fountain
324 BL Cosmetics
324 BR Washroom
325 TL Speech & hearing
325 TR Quiet area
325 BL Megaphone
325 BR Press room
326 TL Fast
326 TR Rotation
326 BL Slow
326 BR Rotation
327 TL Supermarket
327 TR Forklift
327 BL Trumpet
327 BR Food processing
328 TL Open here!
328 TR Mail
328 BL Fragile
328 BR Telephone
329 TL Telegram
329 TR Cloakroom
329 BL Biodegradable
329 BR Raingear
330 TL Trash
330 TR Recycling
330 BL No trash
330 BR Recycling
331 Recycling
332 TL Inkjet
332 TR Offset
332 BL Laser
332 BR Mouse
333 TL,R Address
333 BL Copy machine
333 BR Fax
334 TL Weight
334 TR Gross weight
334 BL Telephone
334 BR Net weight
335 TL Four
335 TR Arrow
335 BL Raingear
335 BR Keep frozen
336 TL Escalator down

336 TR	Escalator up
336 BL	Escalator up
336 BR	Escalator down
337 TL	Escalator up/down
337 TR	Working hours
337 BLR	Lift
338 TL	In
338 TR	Out
338 BL,R	Maintenance
339 TL	Unlock
339 TR	Lock
339 BL	Mechanic
339 BR	Open door or lid
340 TL	Cut
340 TR	Use no hooks
340 BL	Manure
340 BR	Batteries
341 TL	Infinity
341 TR	Incorrect citation
341 BL	Doubtful specimen
341 BR	Specimen verified
342 TL	Typical specimen
342 TR	Fast forward
342 BL	Project
342 BR	Rewind
343 TL	Start
343 TR	Increasing action
343 BL	Start
343 BR	Stop
344,345	Over there!
346 TL	Elections
346 TR	Grief
346 BL	Elections
346 BR	Time
347 TL	Peace
347 TR	Time
347 BL	Skull
347 BR	Wreath
348 TL	Justice
348 TR	Nib
348 BL	Lyre
348 BR	Norwegian traffic sign
349 TL	Type of filter
349 TR	Filter
349 BL	Light and dark
349 BR	Time
350 TL	Close up

350 TR	Macro
350 BL	Night-mode
350 BR	Groups
351 TL	Infinity
351 TR	Zoom
351 BL	Shake
351 BR	Continuous
352 TL	Timer
352 TR	Focal plane
352 BL	Red eye
352 BR	Flash off
353 TL	Battery
353 TR	Projection room
353 BL	Sound annotate
353 BR	Film
354 TL	Queen black
354 TR	Queen white
354 BL	King black
354 BR	King white
355 TL	Bishop black
355 TR	Bishop white
355 BL	Rook black
355 BR	Rook white
356 TL	Knight black
356 TR	Knight white
356 BL	Pawn black
356 BR	Pawn white
357 TL	Spades
357 TR	Hearts
357 BL	Clubs
357 BR	Diamonds